Daylight

Personal History

Carole Glauber

Cofounders: Taj Forer and Michael Itkoff
Creative Director: Ursula Damm
Copy Editor: Gabrielle Fastman

© 2020 Daylight Community Arts Foundation

Photographs © 1987–2016 by Carole Glauber

"A Dreamed Reality" © 2020 by Elinor Carucci
Afterword © 2020 by Carole Glauber
p. 108 © 2020 by Ben Glauber
p. 109 © 2020 by Sam Glauber-Zimra

ISBN 978-1-942084-87-7

Printed by Faenza, Italy

Daylight Books
E-mail: info@daylightbooks.org
Web: www.daylightbooks.org

A Dreamed Reality

I became acquainted with Carole Glauber's work at a time when my own children were almost fifteen and my fear of the upcoming end of my eighteen years with them–the day they would leave home and go to college–was crawling in. In my despair, I was trying to hold onto my early years with them, but suddenly moments from their childhood became blurry; some even felt like they were disappearing, echoing what I felt about my relationship with them shifting, changing. To my horror, there were times from their childhood I now couldn't even remember, and others that had become vague.

Sitting with this body of work for the first time, looking at Glauber's images of her sons and their lives, I was struck by the sense of time slipping away, the sense of fading memories, of kids getting older and becoming adults so quickly. It is beautiful yet painful at the same time. Moments we lived so vividly, with such intensity, become hazy, defused, faded. Over time, the period of our children's childhood gets colored–sometimes idealized, sometimes romanticized. Looking at Glauber's photographs, it felt like this inevitable process was happening in the images themselves, their lack of clearness leaving us to wonder: Was this how it was, or is it how it is being remembered? The images so beautifully give the viewers the impression that they are already altered through, and by, time.

Glauber's work deals with the themes of raising children, of travel, of family–a specific family. Yet it is also the very common notion of loss, an "everyday" loss, that we feel the most as parents, as mothers, going through the journey of raising our children, preparing them and ourselves for the day we will part and send them on their way, hopefully ready. And then be left with memories and moments. With weeks, months, and years that fly by, yes, just as the cliché says, they do fly by. The older we get, the faster they fly.

This feeling of the fleeting nature of time is also intensified by the tight edit, by letting a limited number of images tell the story, sometimes letting months go by before we see the next photograph–how quickly we

see the boys turning into young men. Carole Glauber captures moments as they are stored in our brains, doing so in part with the use of a particular technique created by her choice to use a 1950s Kodak Brownie Hawkeye camera. Choosing this aesthetic, she walks the line between images that feel composed and intentional, and some that feel almost on the verge of vernacular photography, and so creates an authentic and intimate feeling, having the images move between private and voyeuristic, often using the aesthetic of family album and snapshot photography. Those elements resonate with the work of the Swiss photographer Annelies Štrba, especially with her body of work about her daughters and grandchildren, *Shades of Time*. Štrba also uses the language of the snapshot, bringing authenticity and realness to her images. Like Glauber, Štrba constructs a quality of fantastical narrative in her pictures: a personal story is being told, but a more universal moment is being represented.

It was Nan Goldin, the master of the snapshot as genre in the art of photography, who said, "Snapshots are the only form of photography that are completely inspired by love." Glauber's work is inspired by love. We are taken with her into glimpses of the journey of raising children, watching them grow, and of how she and all of us remember. The story is universal, though we do get a few specific milestones: the arrival of another child in the family, a baby, a Bar Mitzvah, a graduation, and then what seems like a move to another country–which in a subtle way touches the immigrant Israeli-American in me deeply–reminding us of the constant duality between the private and the public, the universal and the specific. How close and how far they can be from one another.

When I got to the last image, I felt nostalgic. Nostalgic for memories and sparks of life of people I never met or knew–for someone else's family. I was touched. Touched by the intimacy and the magic of those moments, the magic of the light sometimes glowing back at us. As a viewer, there was a sense that I might never know some of the stories behind those images, but I might think about my own.

As if I had visited someone else's dream.

–Elinor Carucci

Dreams of soft twilight
You have been for us as eyes
Upon our journey

–Carole Glauber

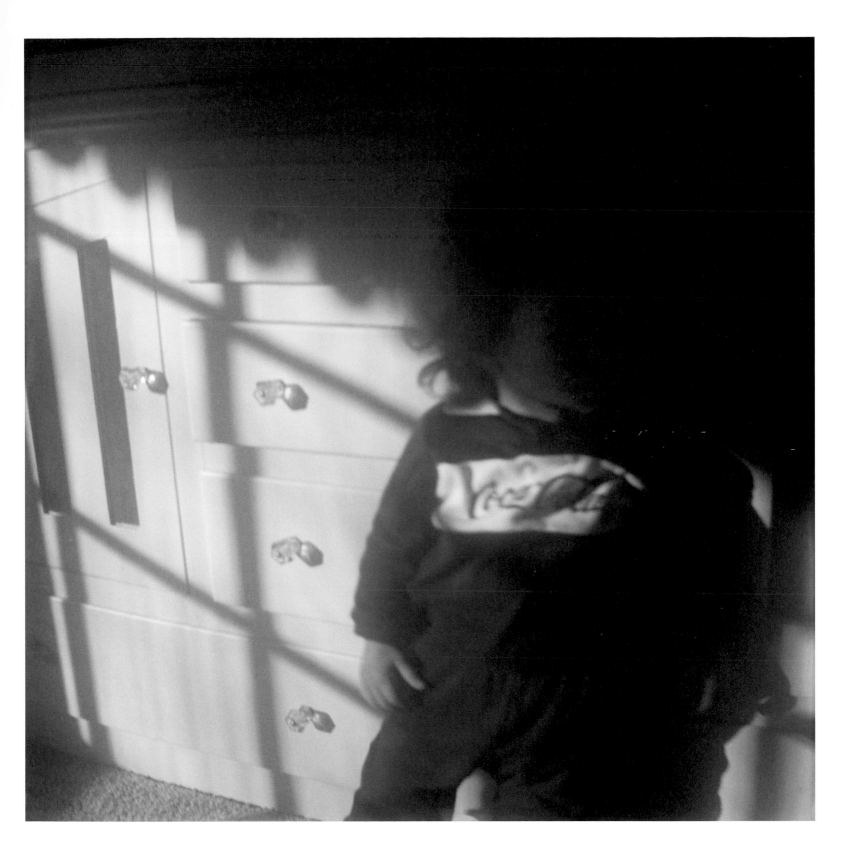

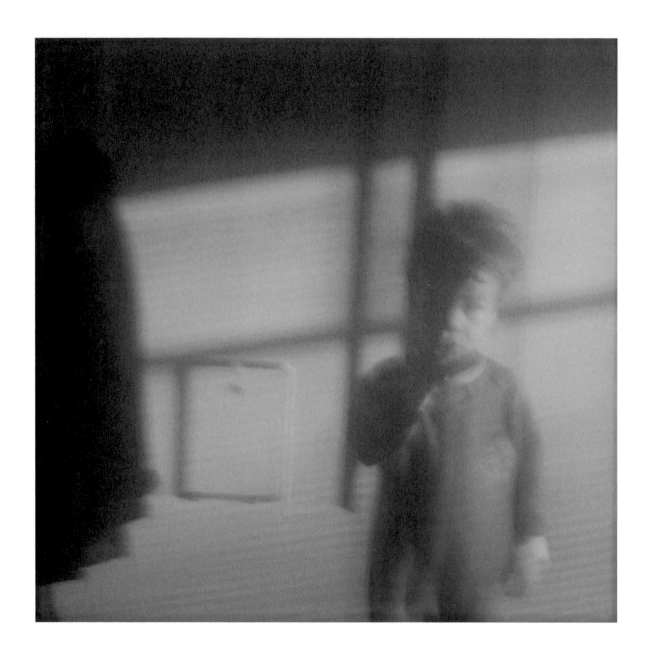

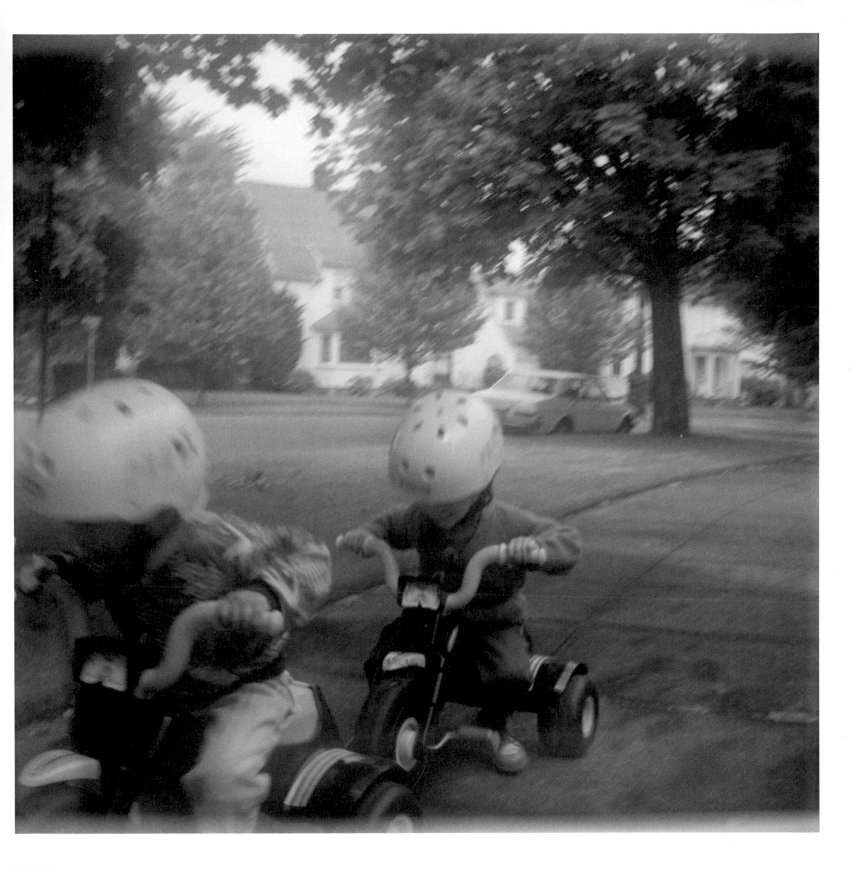

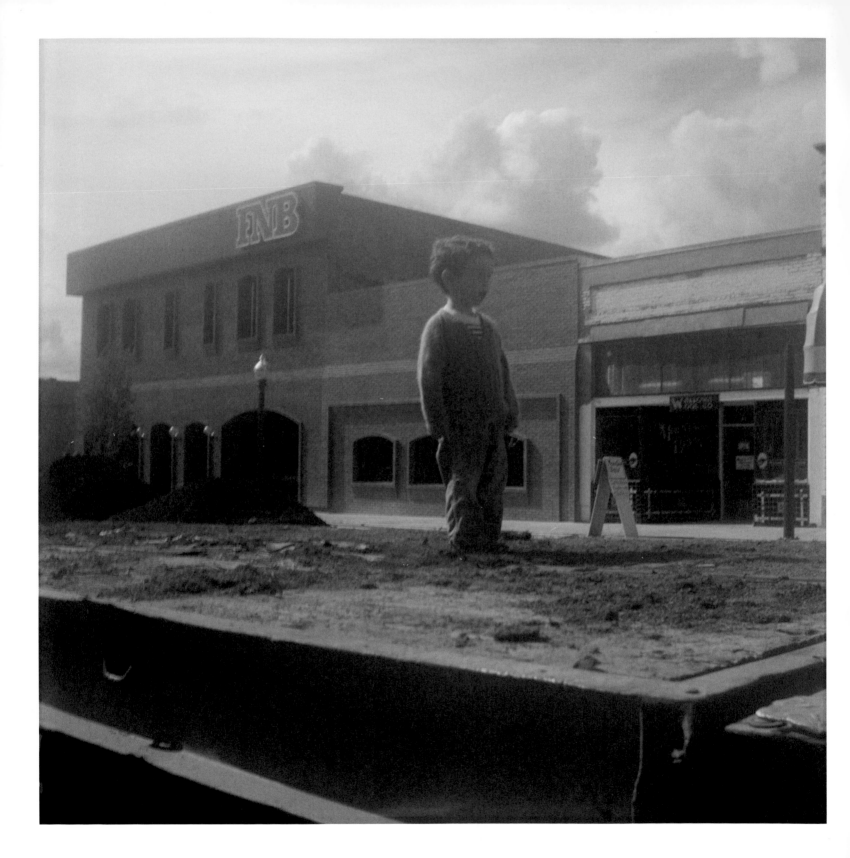

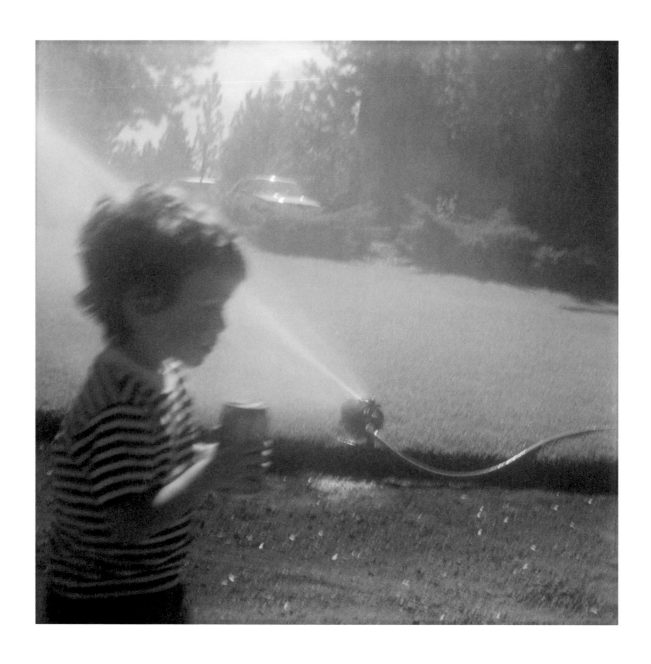

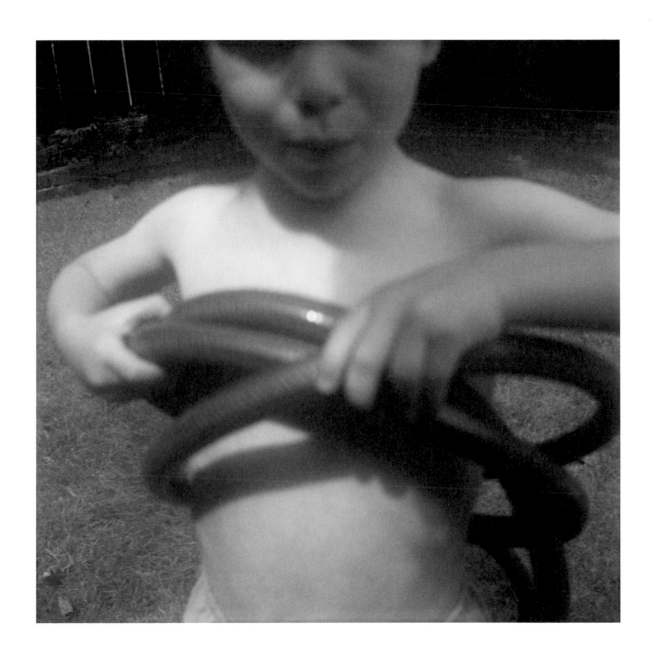

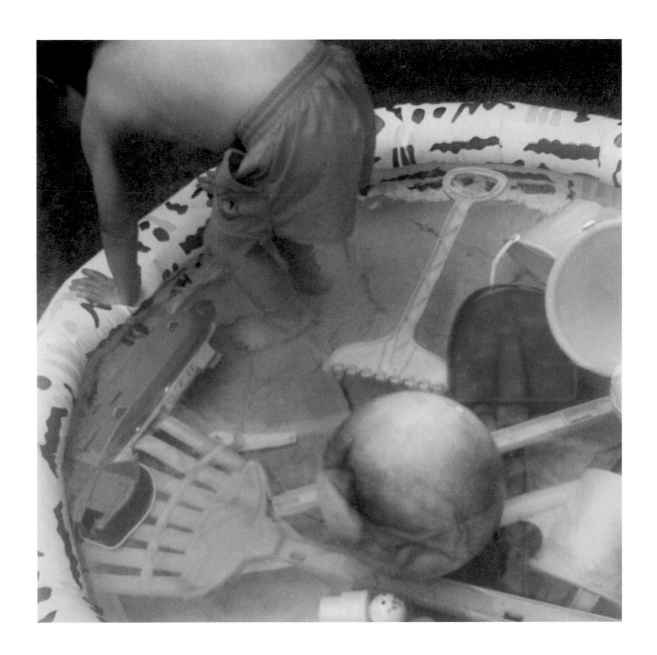

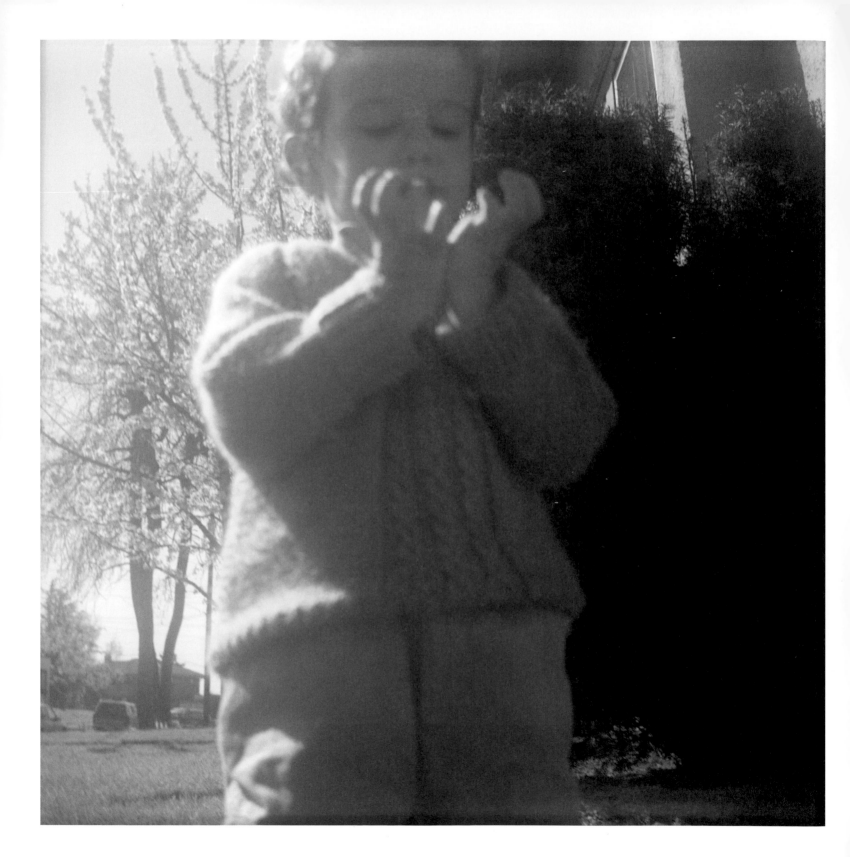

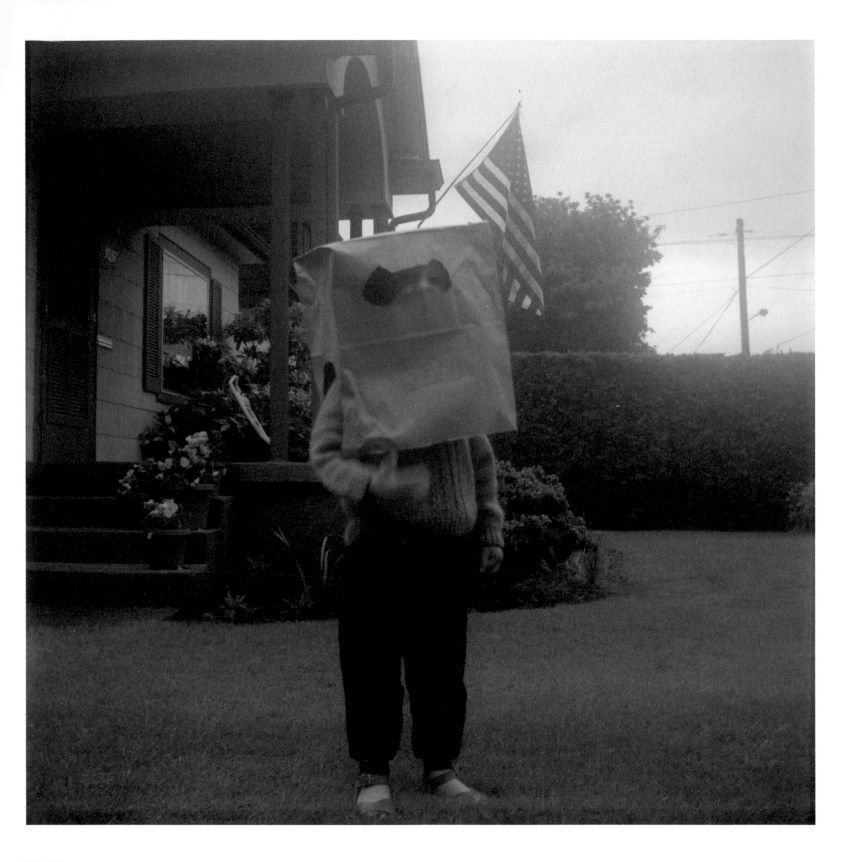

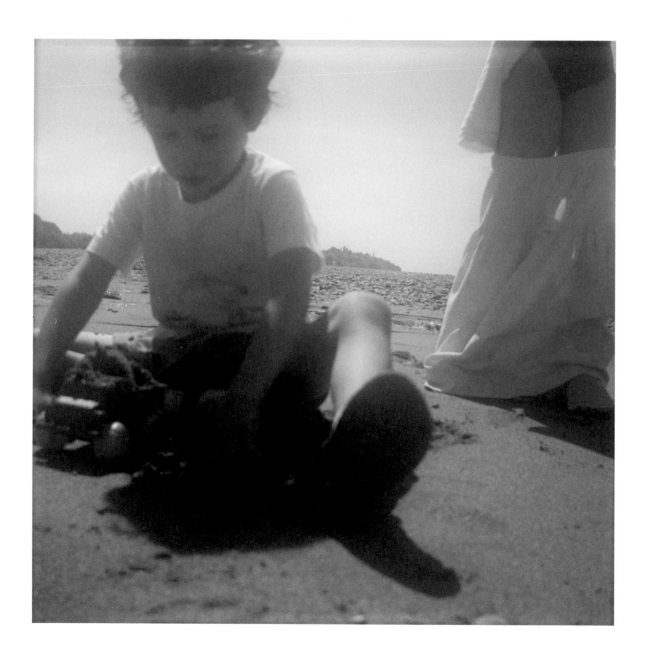

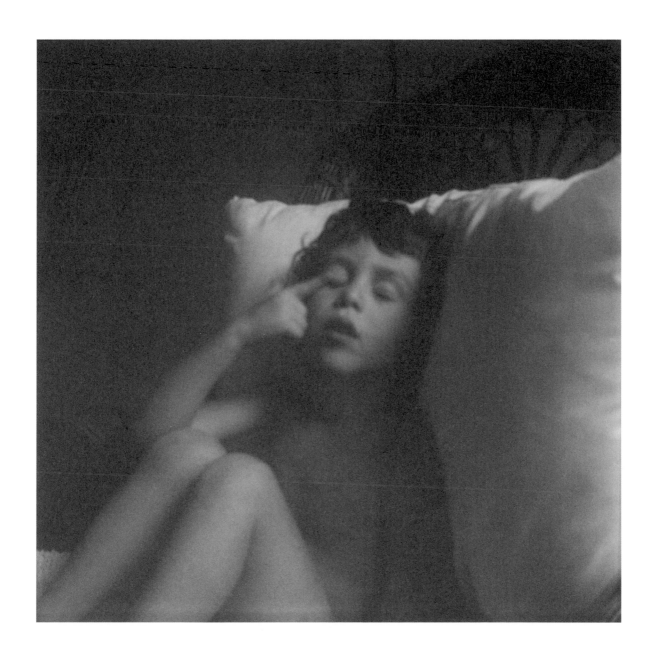

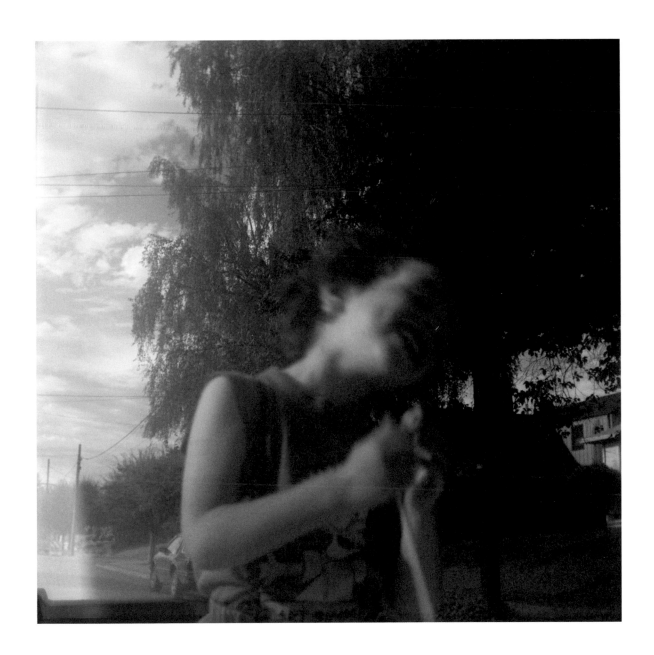

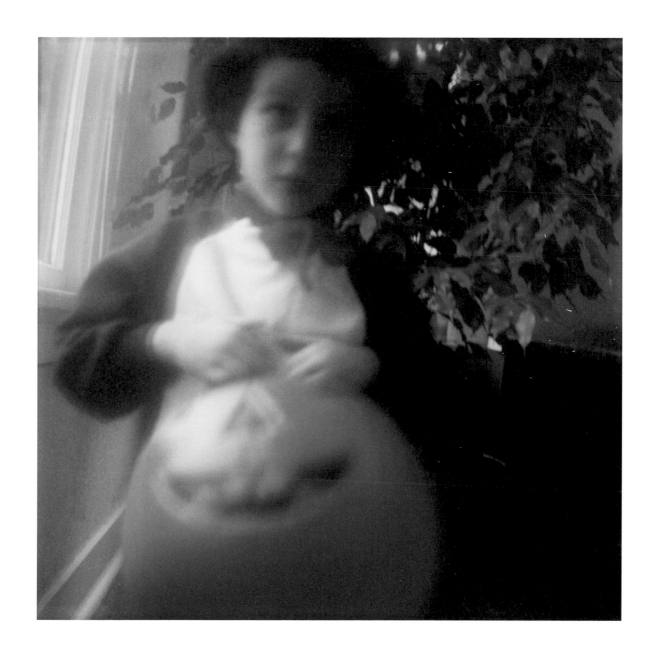

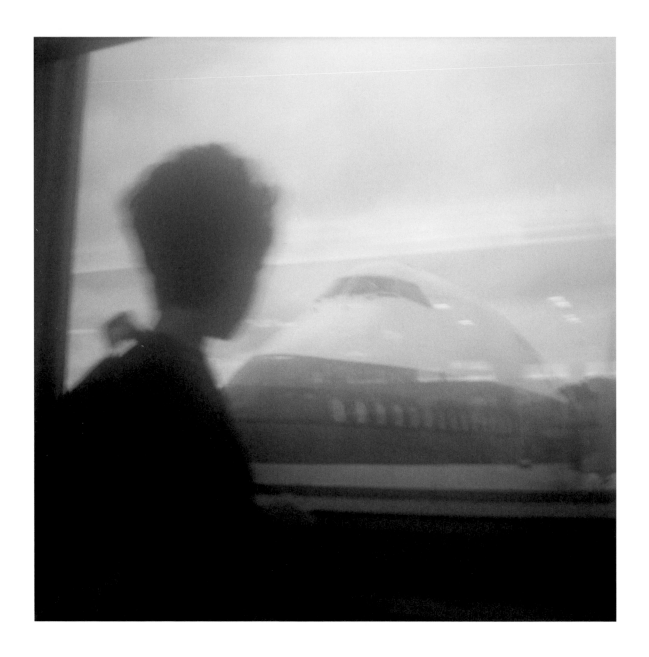

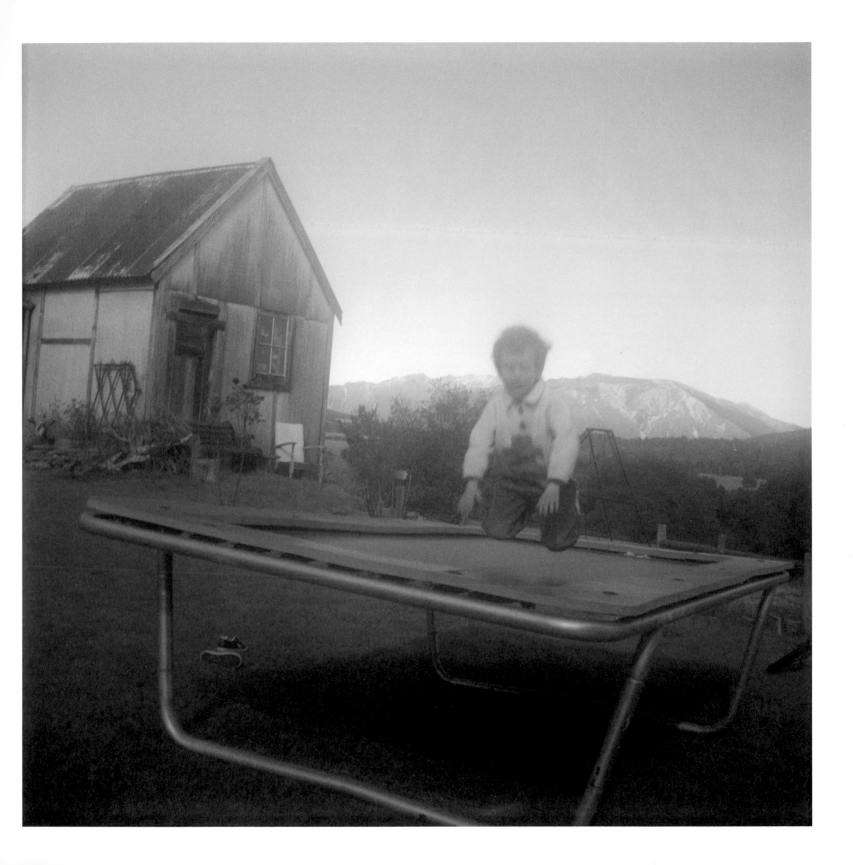

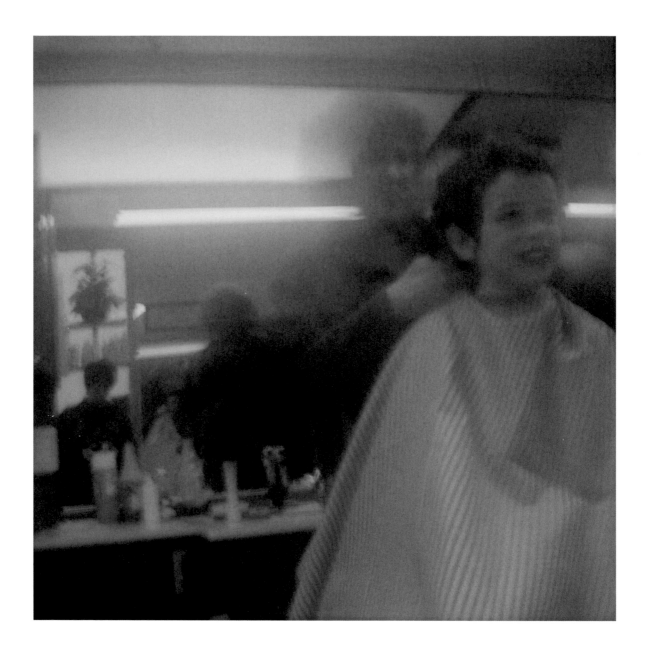

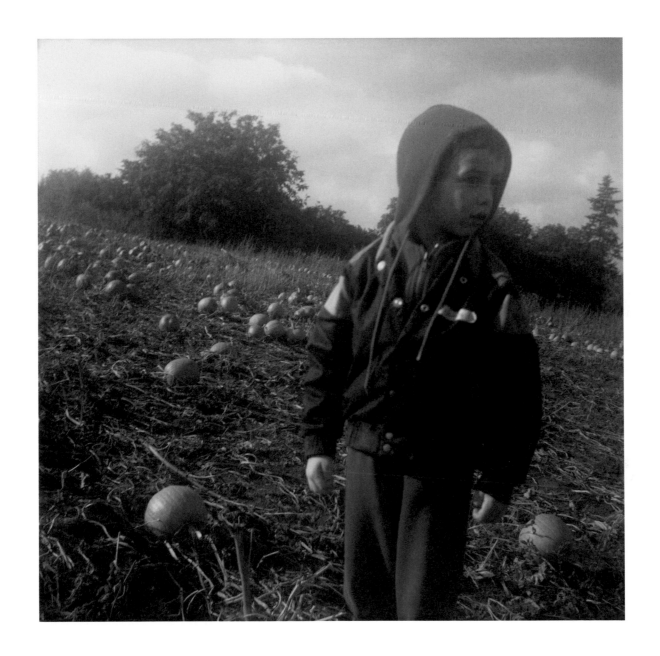

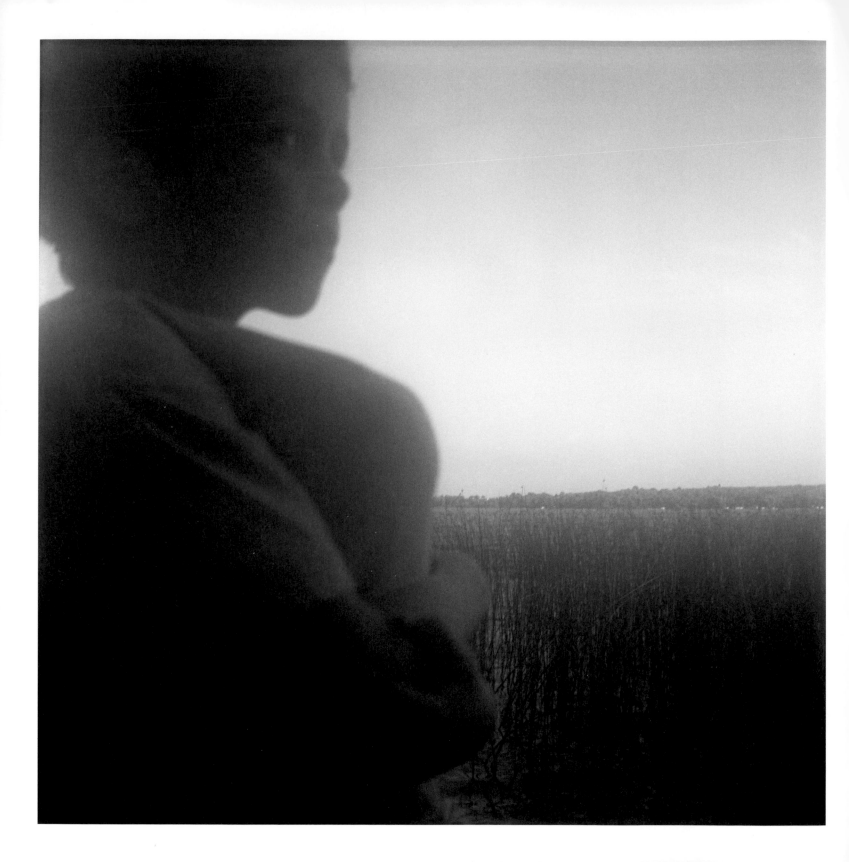

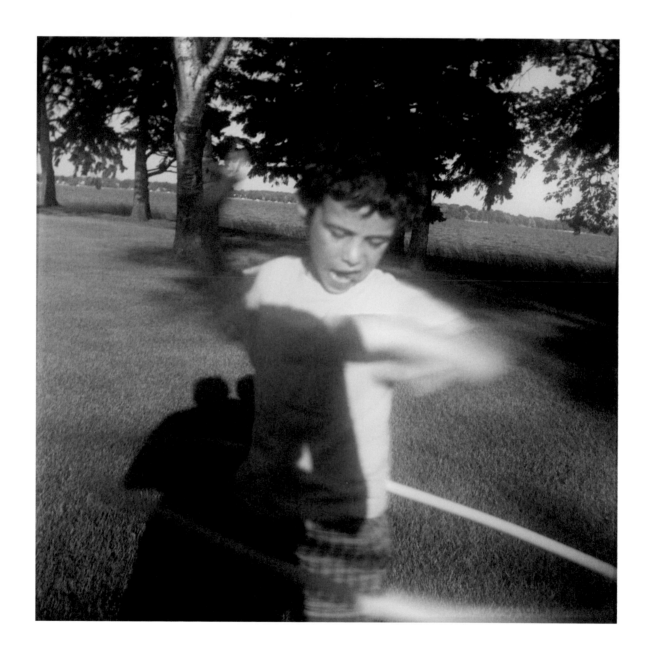

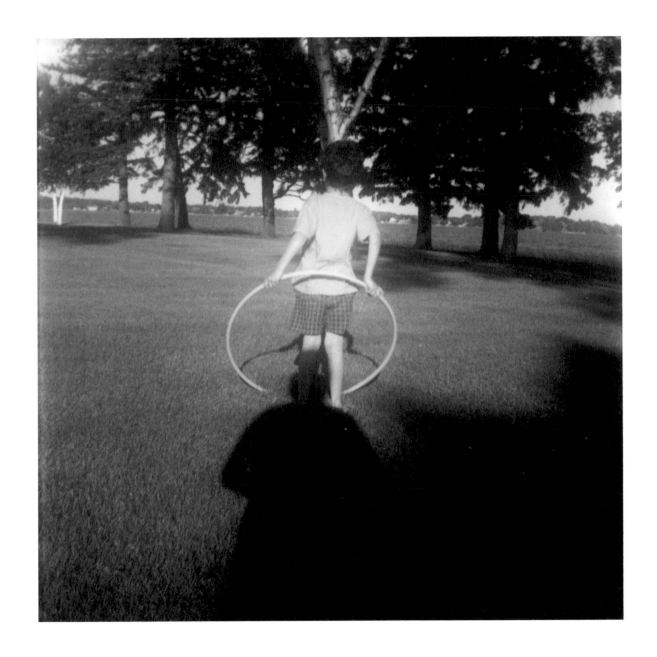

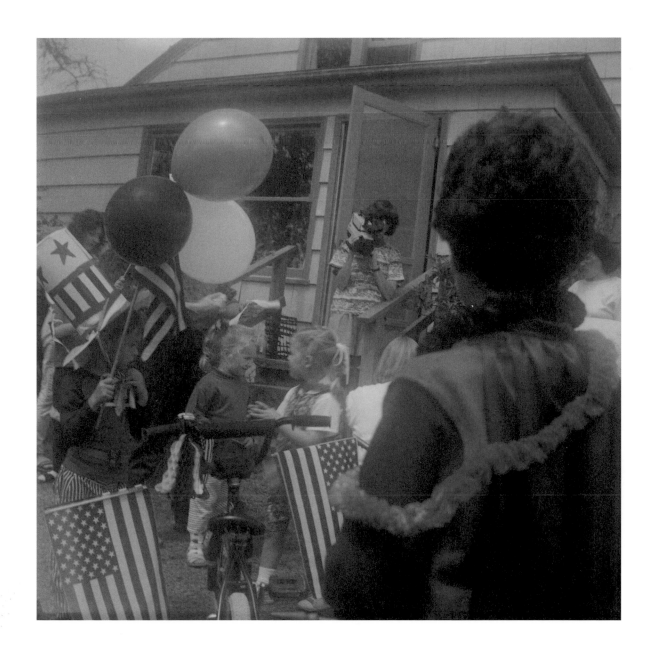

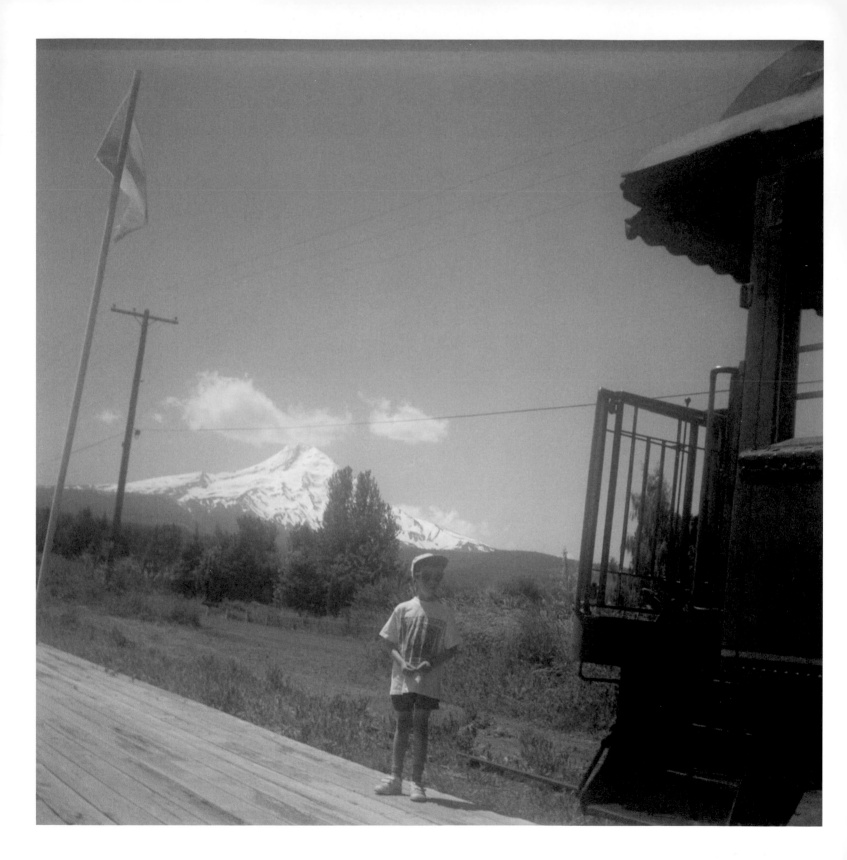

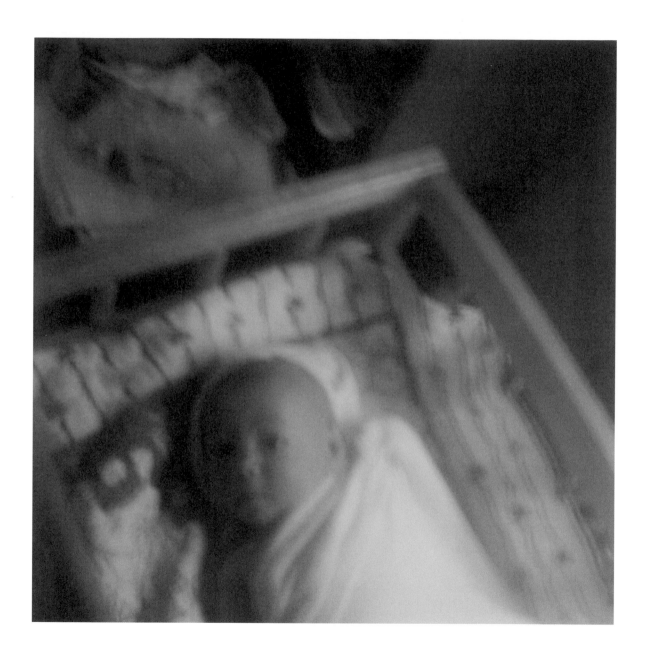

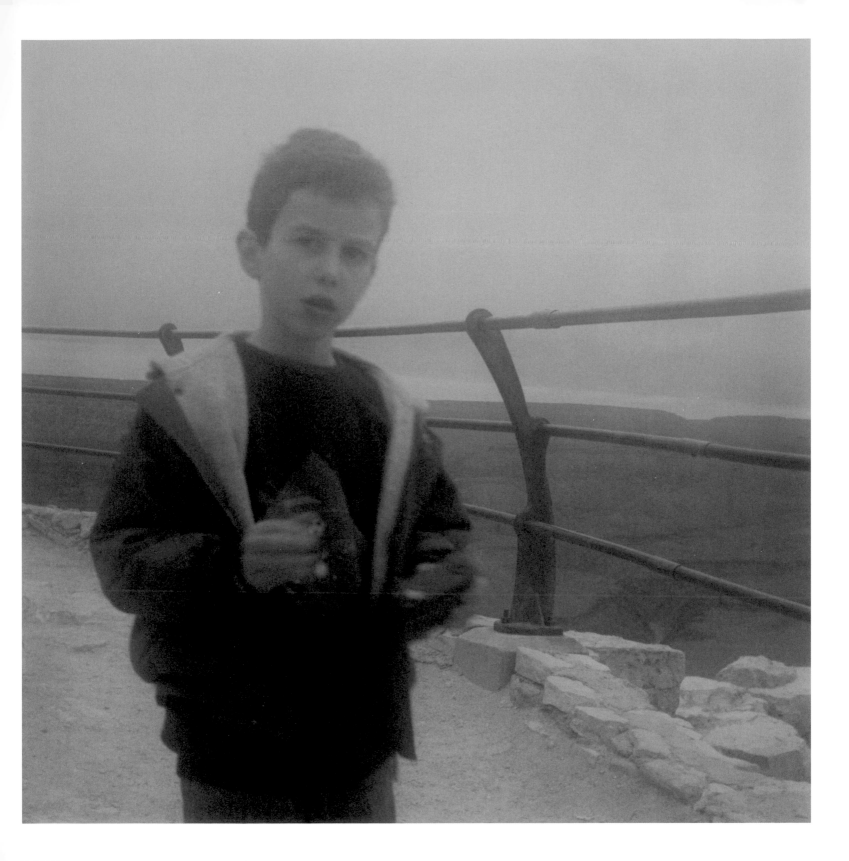

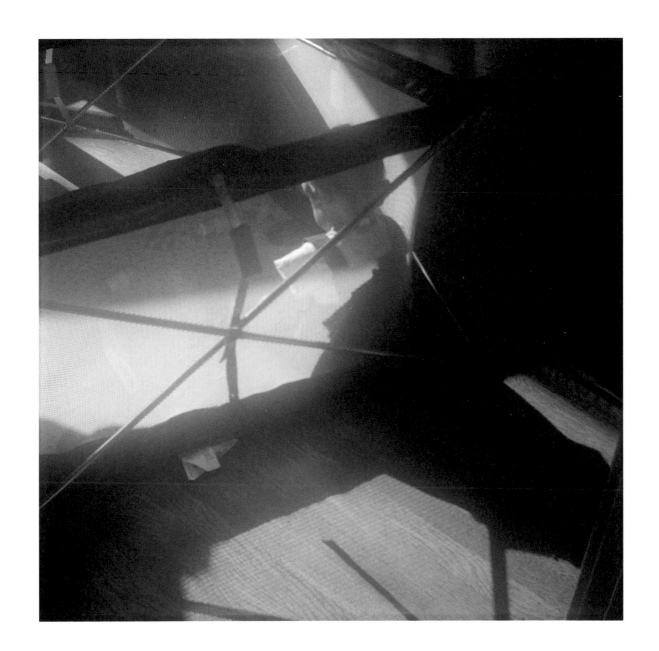

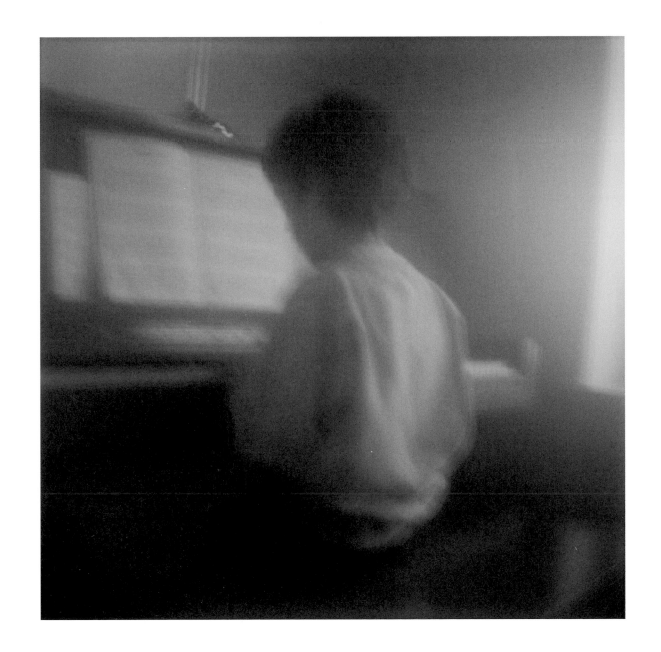

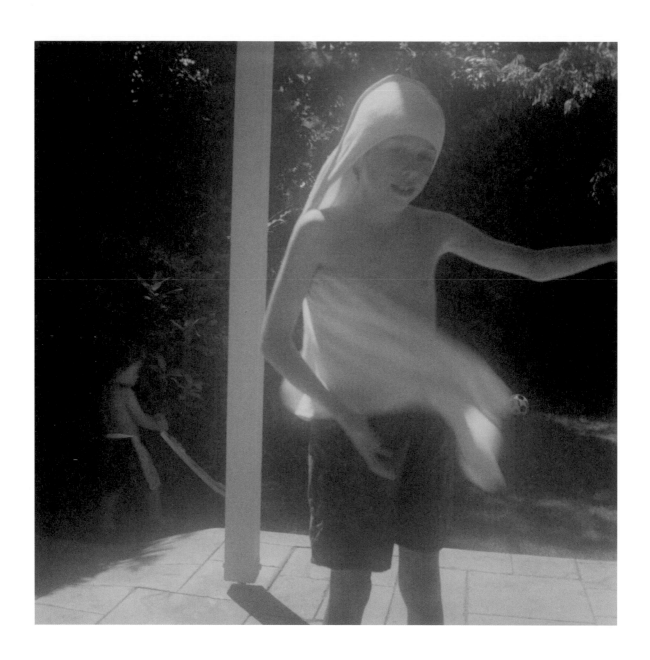

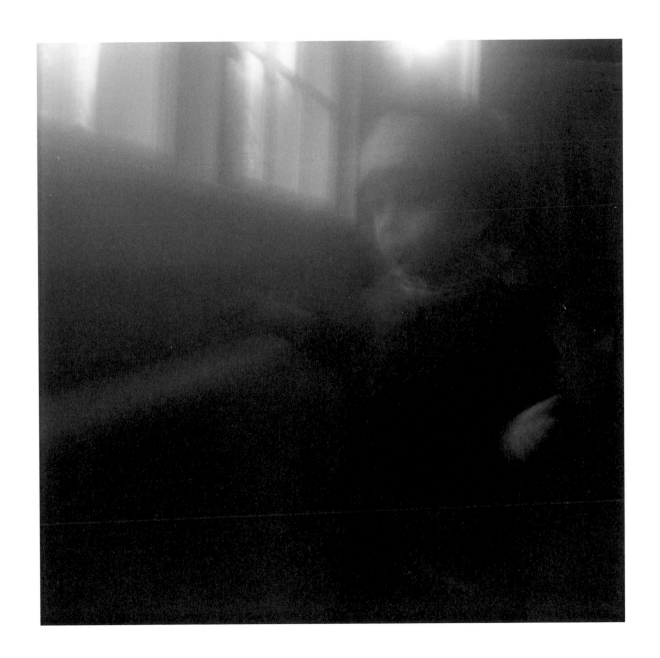

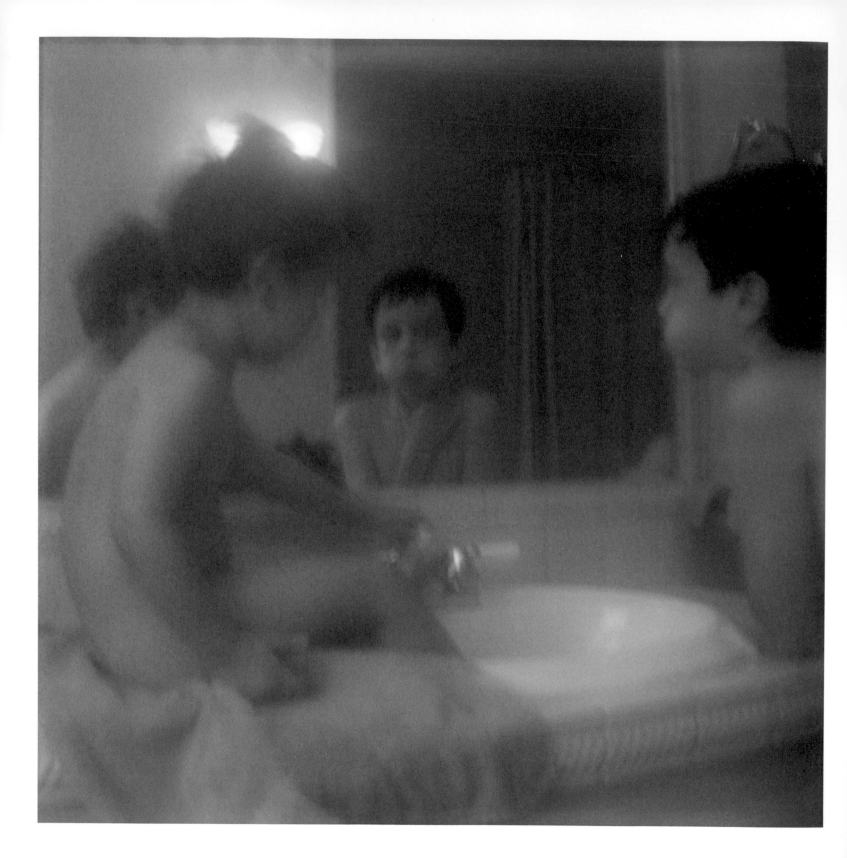

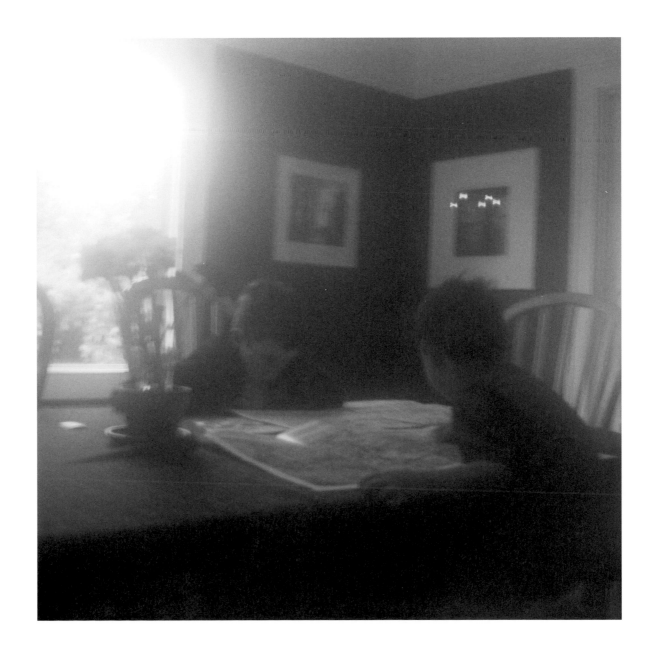

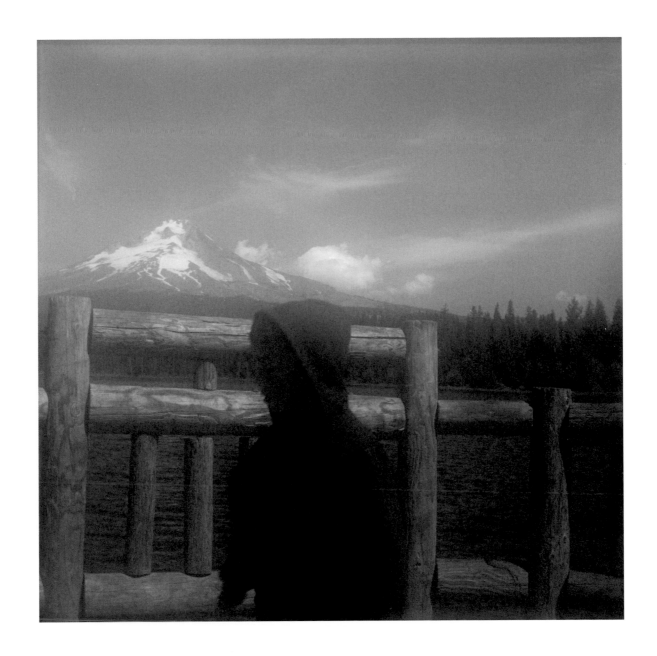

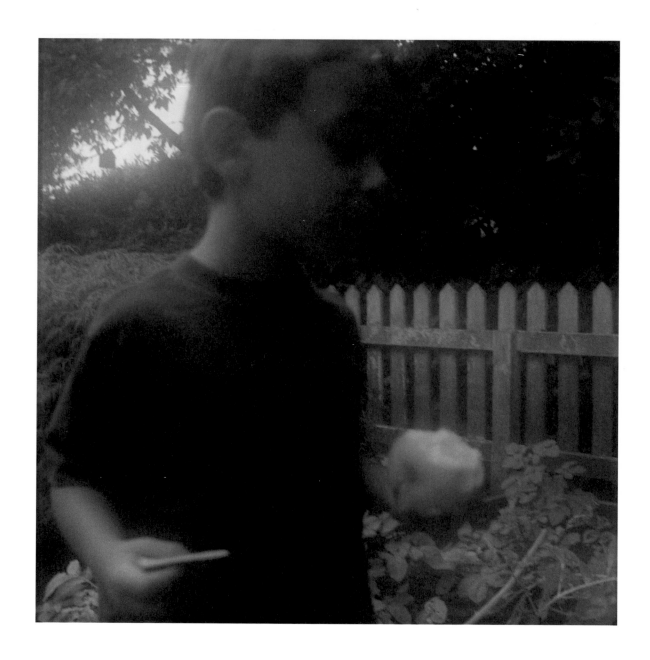

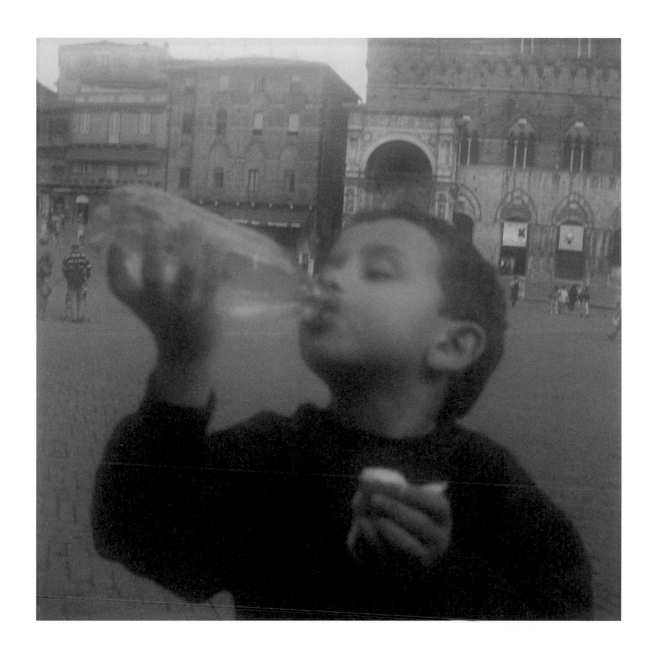

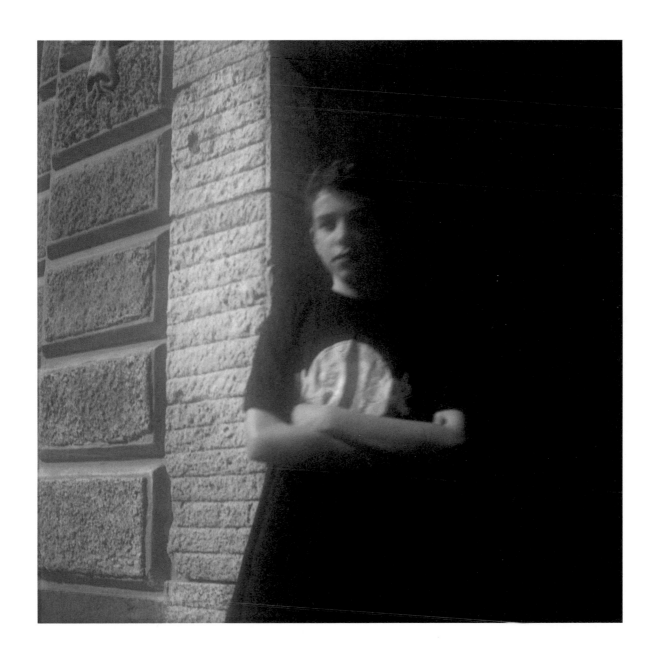

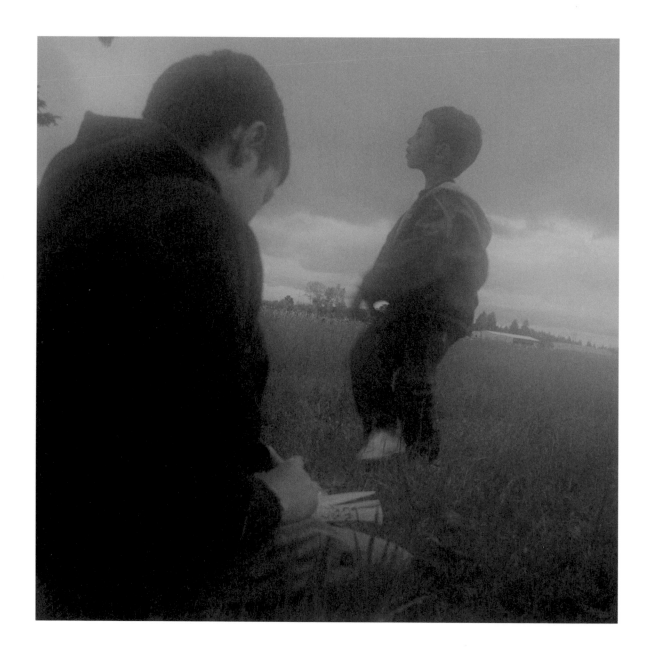

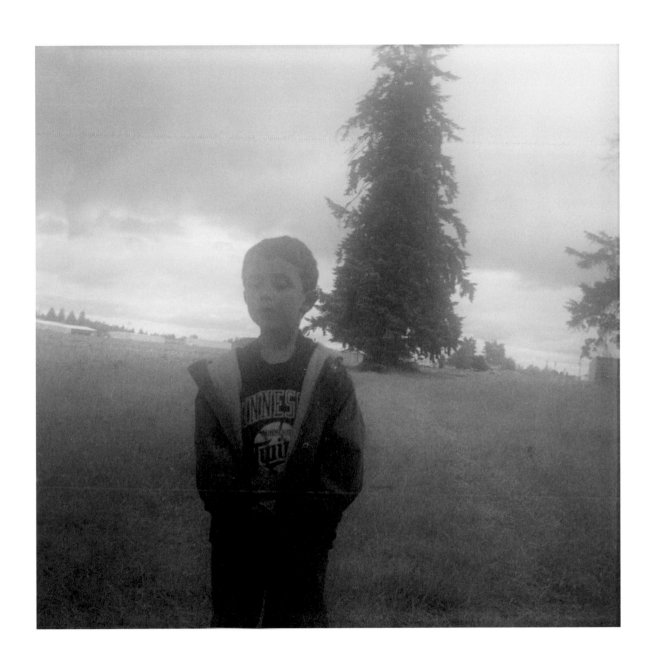

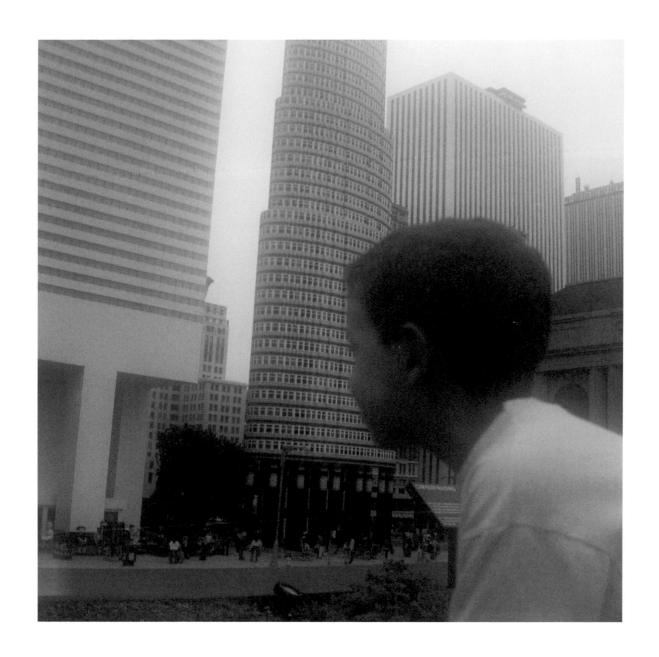

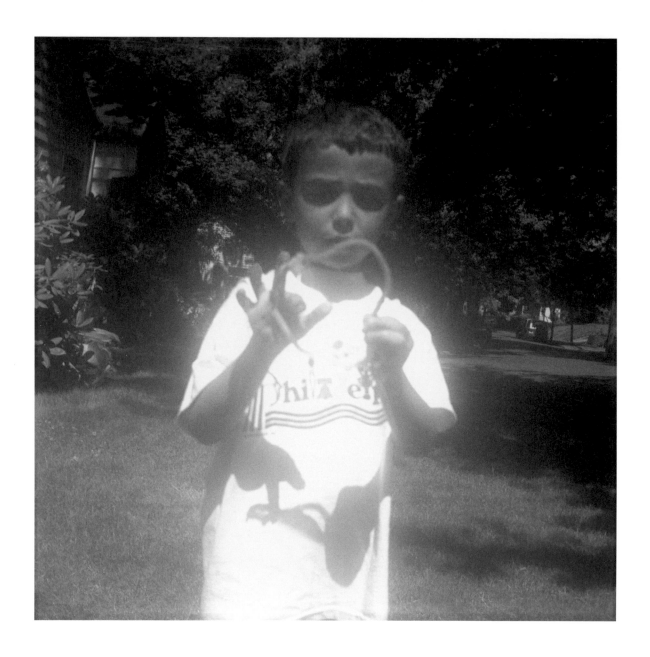

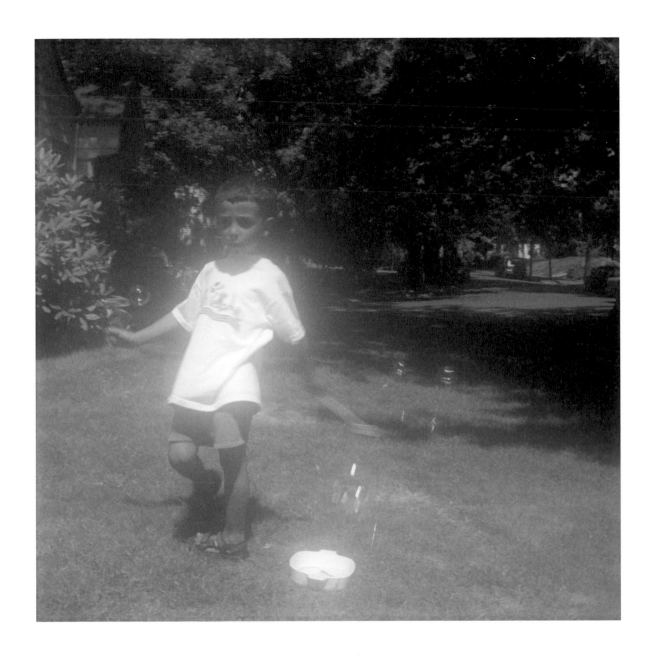

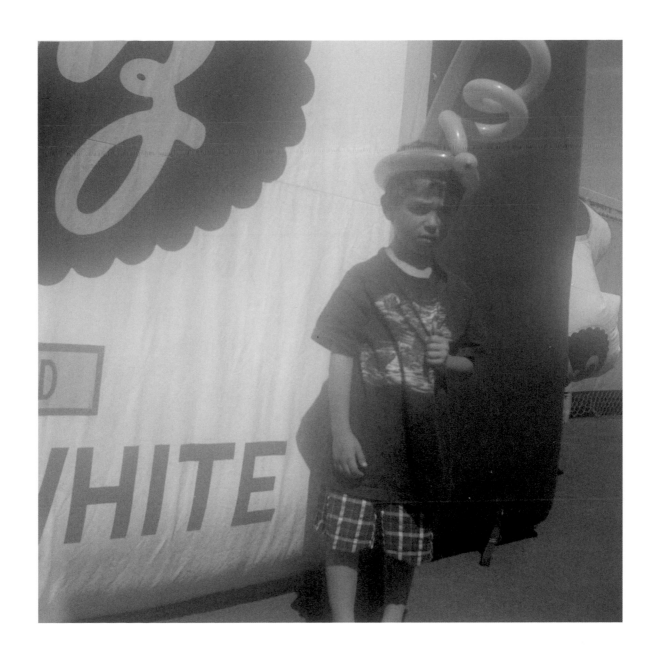

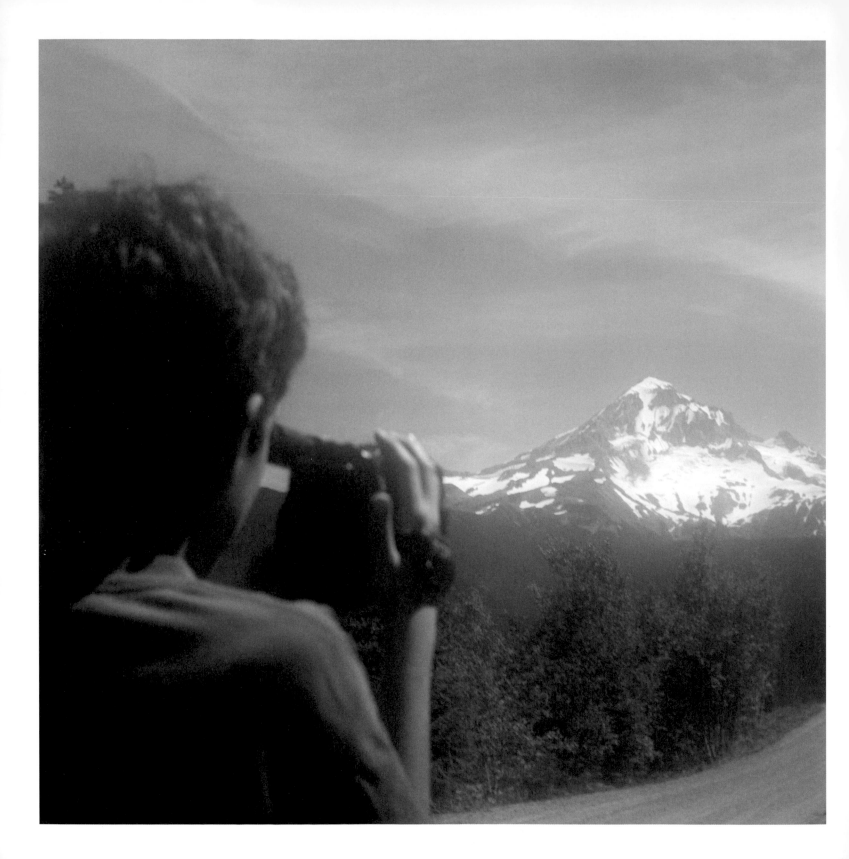

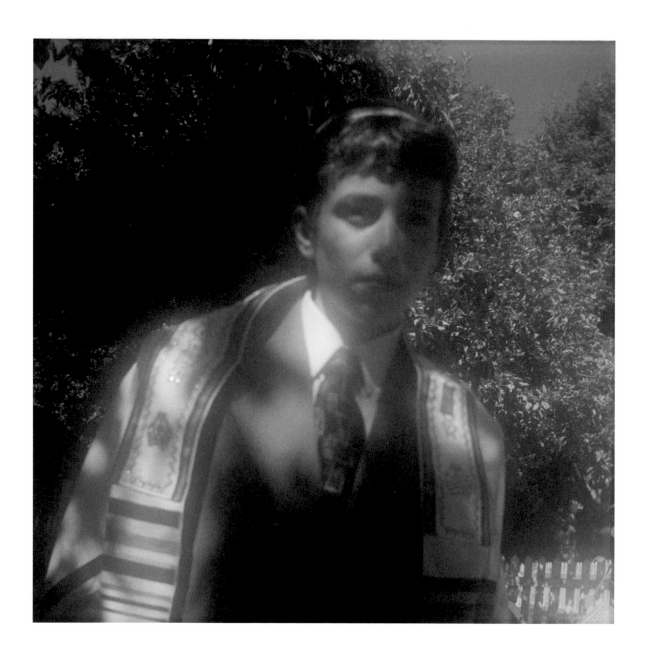

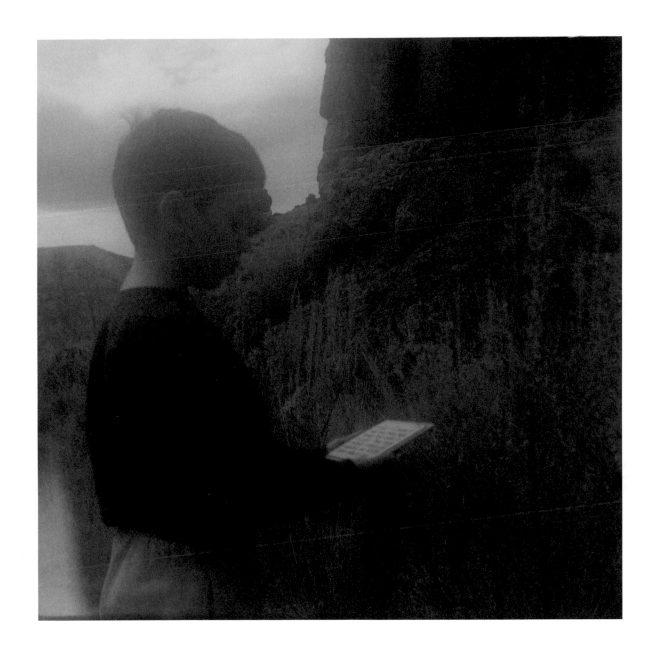

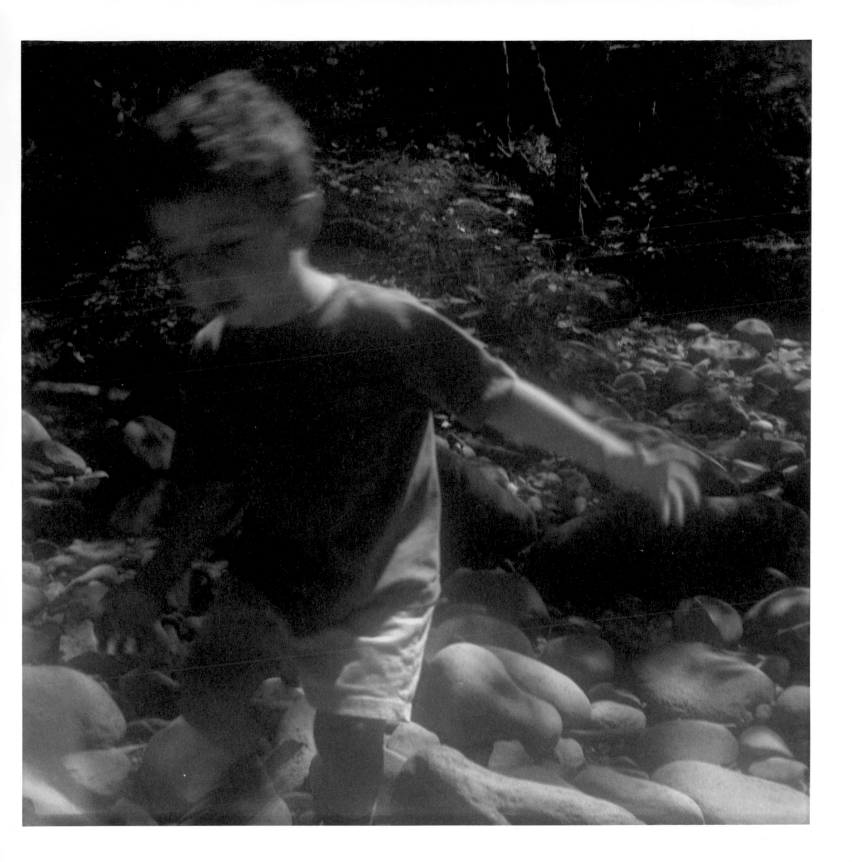

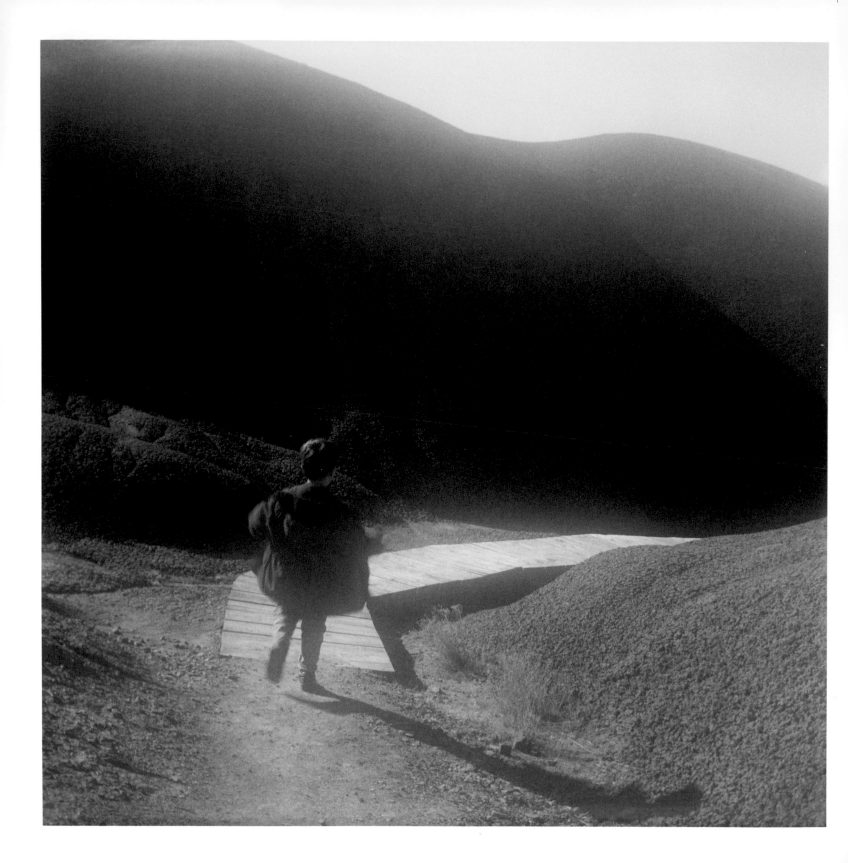

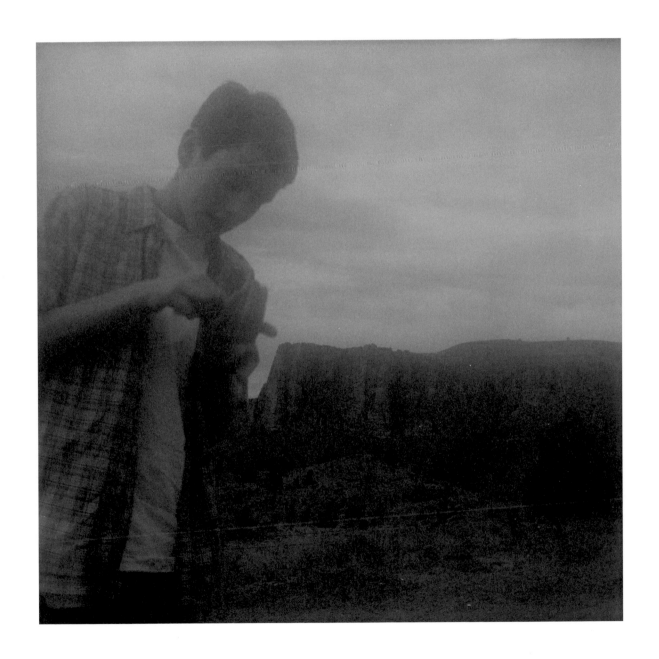

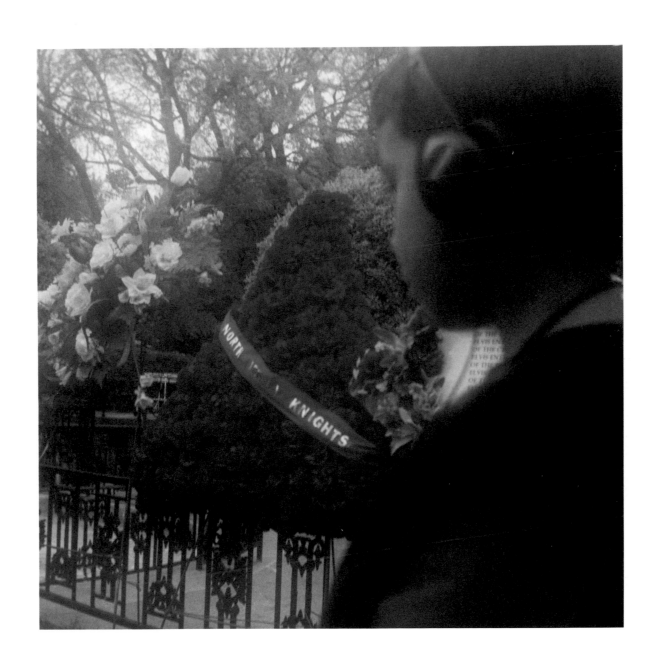

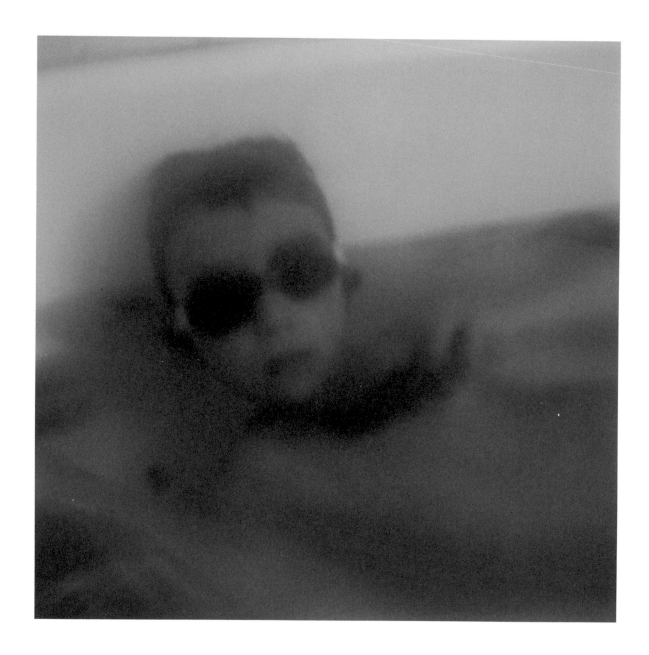

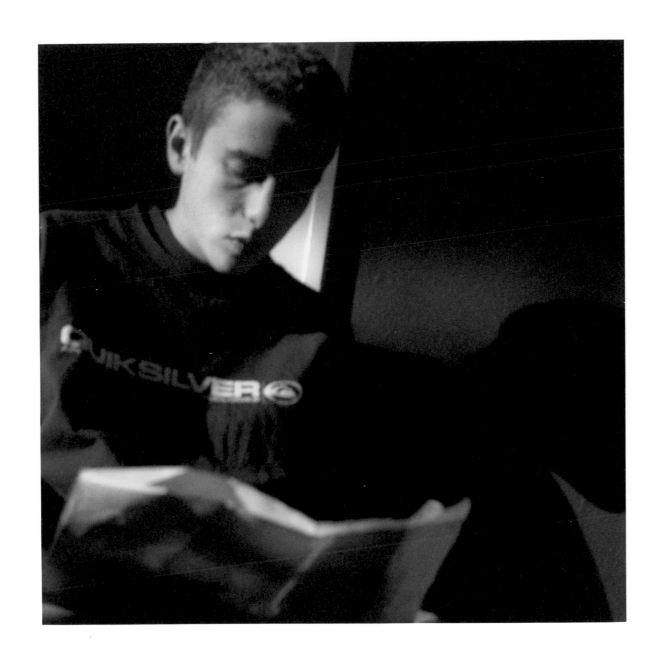

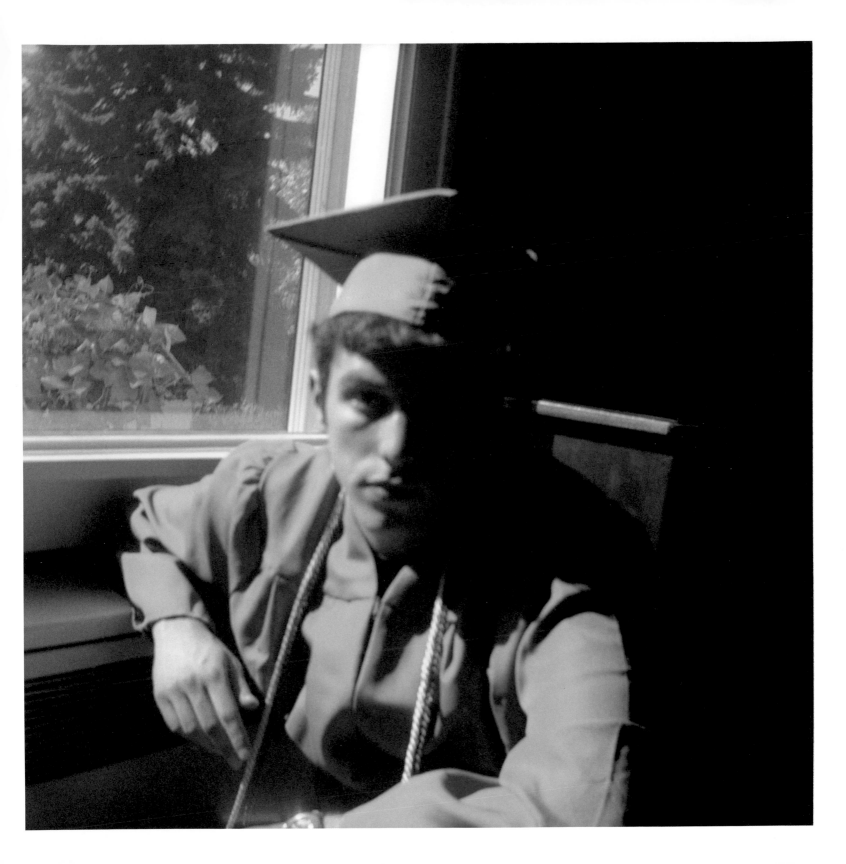

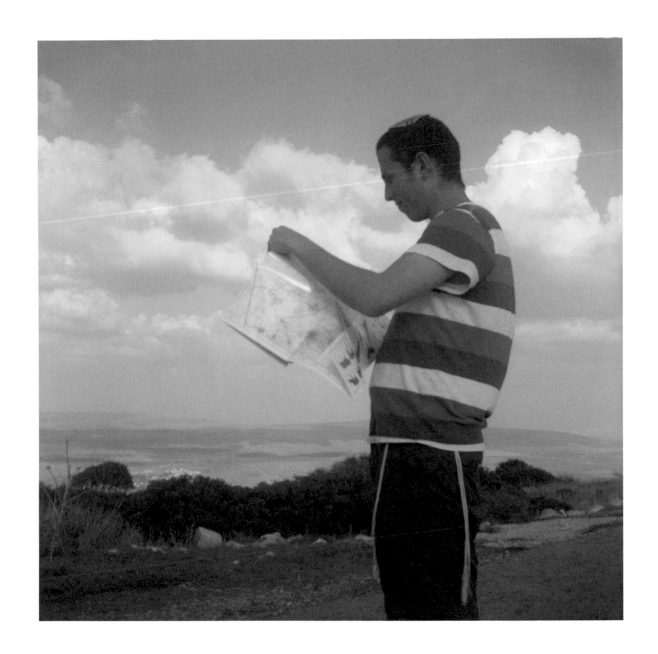

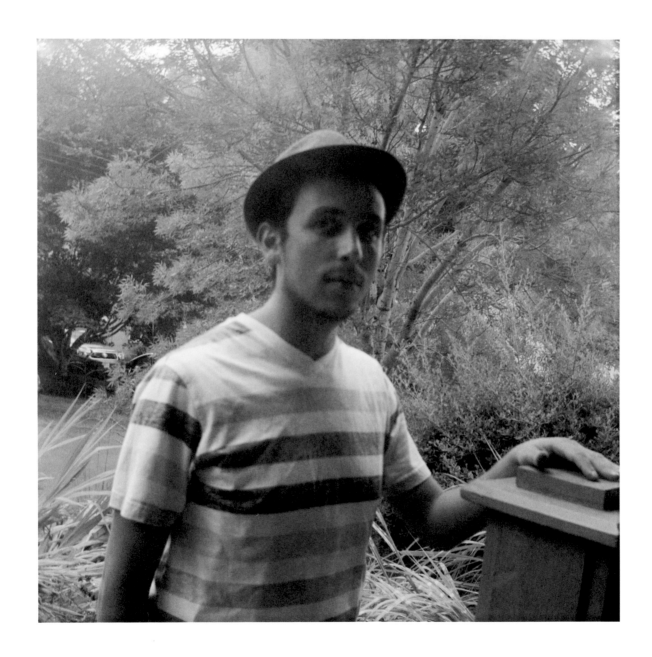

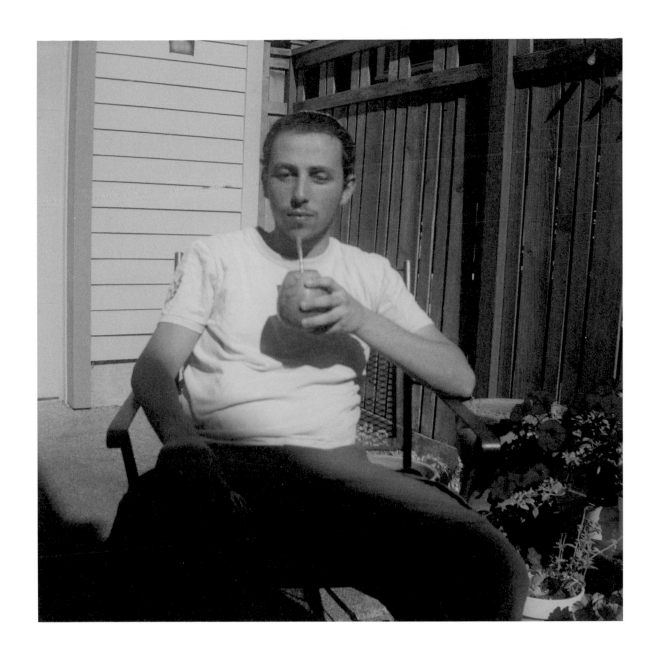

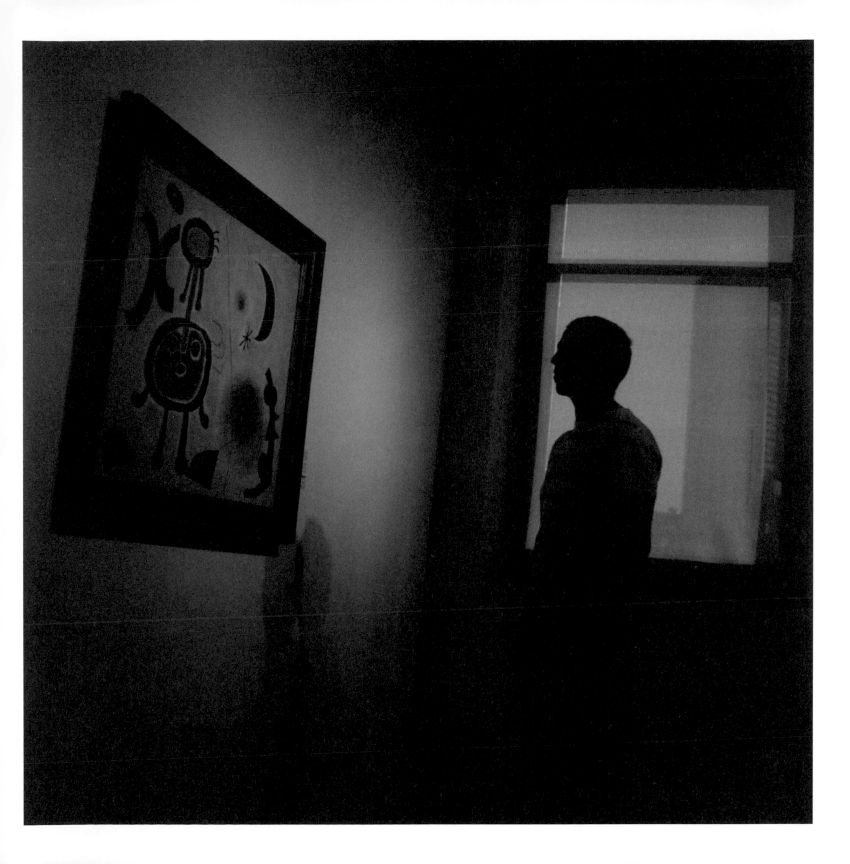

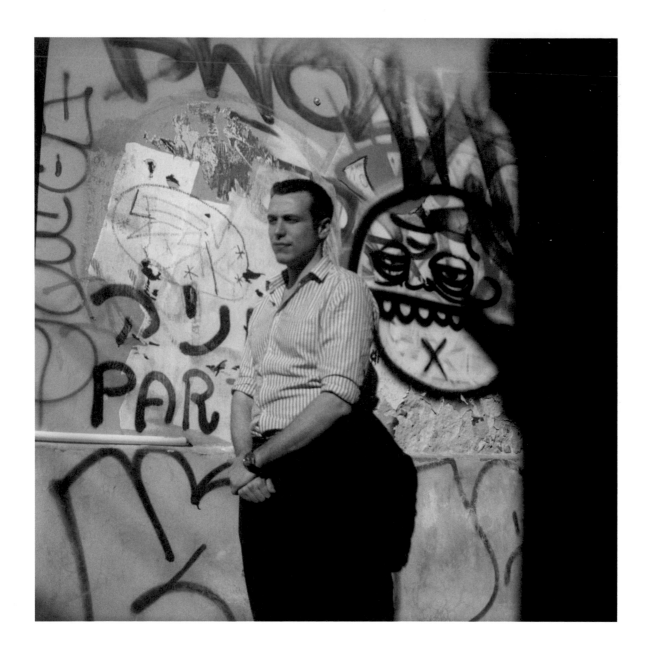

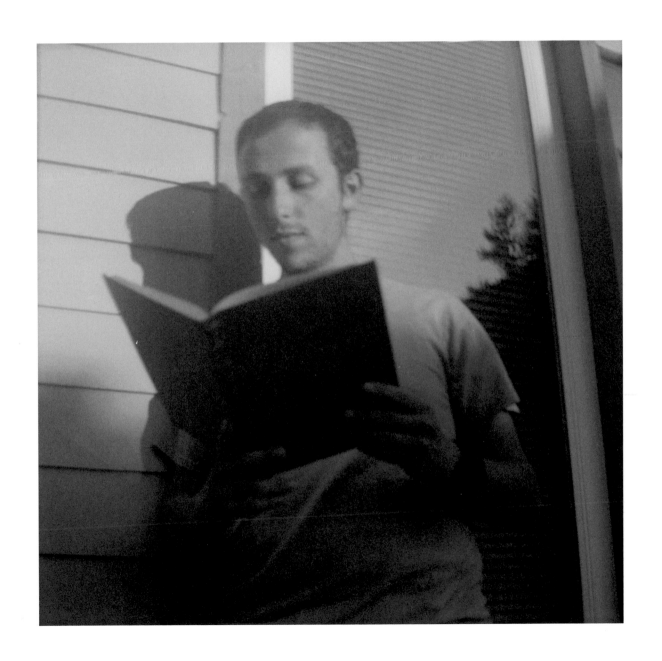

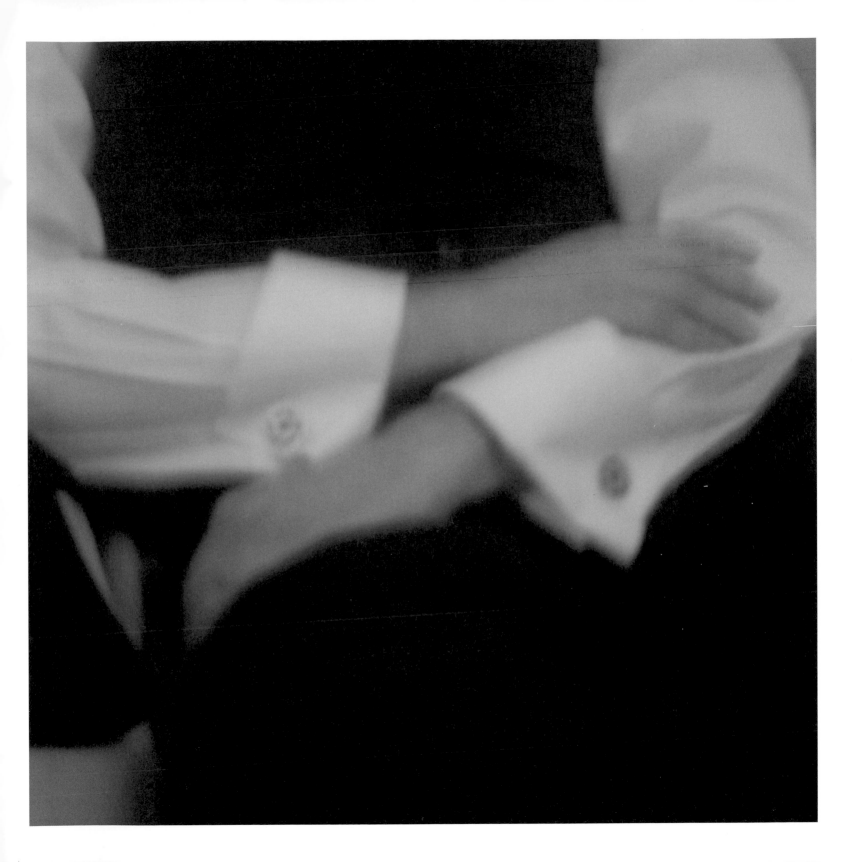

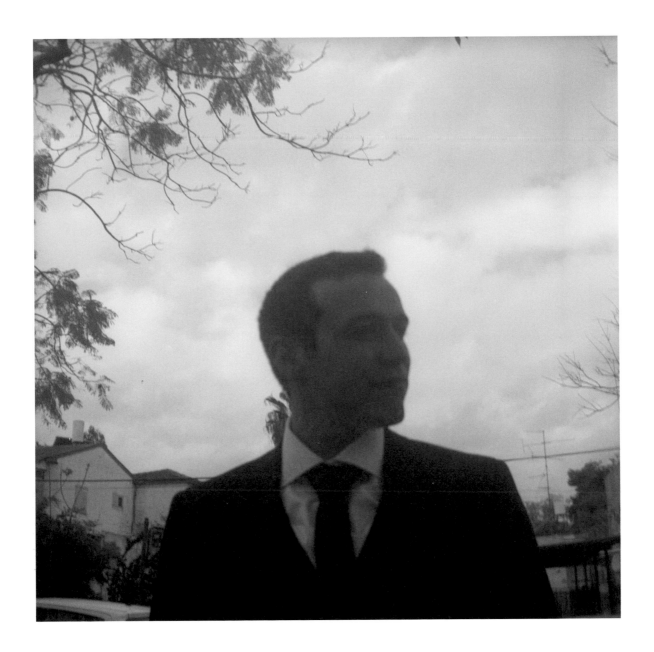

Platelist

Afterword

In much of the world, people are expected to appear outwardly strong and secure. To be the subject in a photograph, however, involves a certain amount of vulnerability. When we participate in a photograph, the possibility exists of that moment shifting from personal to public. This photographic realignment transforms our concealed selves into a potential shared consciousness. Photographing my sons, Ben and Sam, for so many years, and visibly sharing my results, placed them in the category of moving from a private space to the public eye. This involvement created innumerable paths connecting one place to the next, with many stops and starts along the way. I began to recognize a degree of contemplation in the moment, learning that in many ways we are all one.

As our children grow, we watch them evolve as sentient beings, but when a photograph is made, all but the visible disappears. The feeling of hot and cold, sound and quiet, wind and breeze, or the touch of rough or smooth all evaporate into visual sensation alone. We are left with a degree of self-reflection combined with pictorial solitude.

The years of recording my sons with a Brownie Hawkeye camera underscored my awareness that our children are gifts. They have their own wisdom and their own way of exploring the world. The camera allowed me to witness and preserve aspects of their lives on a personal level by connecting to their external lives as interpreted by my internal self.

During childhood, everything is fresh. It becomes a journey of observing and understanding the circumstances and events that create our lives as we move into adolescence and young adulthood. There is a universal aspect to this passage of time, to meeting the unknown, a collaboration between individuals, this complexity of perceptions, and recording of gesture. My sons share in the creation of these images. They are now Ben and Sam's personal history.

–Carole Glauber

When I was a kid, my mom seemed to always have a camera in her hand. Of course I don't remember the first picture in this book, taken when I was just one year old, but one of my earliest clear memories relates to the photograph where I am walking and drinking from a can of soda. The colors are blurred and diffused, like in a hazy memory, but I can still recall the sunlight and the impossible sweetness and sharpness of the bubbles.

It is a unique situation that my brother's and my childhood photos are also an expression of an artist's creative vision. It is more common for childhood photos to sit in albums on shelves, to be taken out and admired on special occasions. Or, in the age of social media, children today may find their photos spread across the internet. The memories are transiently documented, but the power of a single moment is diluted.

I actually have mixed feeling about these photos. They document a range of normal childhood, adolescent, and young adult moments, not posed with fake smiles, but existing as a more authentic and spontaneous reflection of daily life. It is not always easy to have one's personal memories displayed on gallery walls and published in books, but I am happy for my mom's success as a photographer and proud to be a subject of her work.

–Ben Glauber

My mother's camera has accompanied me since my earliest years, and the photographs collected in this book depict me from the first weeks of my life to the recent years of my early adulthood. Reflecting on the images and the outline they present of my life, I am drawn to the maps and paths that recur in several of the photographs. In one image, I am sitting at our dining room table facing my brother Ben. Tied together by the common color of our red shirts and the burgundy walls around us, we are each engrossed in our reading. I look at my four-year-old self peering deeply into a map. Already at that age I was fascinated by maps and the countries and regions they showed, each delineated by fine lines and different colors. A map represents a journey as well, a seemingly endless variety of paths open to the adventurous. The sense of setting out is well conveyed in an image of my young self running toward a wooden walkway in the Painted Hills of Oregon. Where will this trail take me as it winds its way between the hills? That question is left for the viewers to answer, for the endpoint of the walkway curves away behind a nearby slope, hidden from the observer.

In a later image, I am now an adult, twenty-two years old. I am holding a map, yet the eye of the viewer is drawn beyond me. I am overshadowed by the breathtaking expanse that lies beyond me and the enormity of the cloud-strewn heavens overhead. I must lower the map and peer out at my surroundings. The map may have taken me to this point, but I must not forget to look beyond it as well. It remains in my hand, but I must rise up and make my way on my own. As the subject of many of the photographs presented in this book, these images portray my growth from childhood through adolescence and onward to adulthood, a pictorial map of my own maturation. On the occasion of their publication, it is my wish and hope that others find their own journeys, and those of their children, reflected in my mother's photographs.

–Sam Glauber-Zimra

Acknowledgments

In the many years that have passed since the beginning of this series of photographs and the making of this book, countless people along the way have contributed encouragement, critiques, and understanding of my approach, and to them I am indebted. I also wish to thank Michael Itkoff at Daylight Books, Etty Schwartz at The Print House, for her technical expertise and photographic wisdom, Ursula Damm, for her thoughtful book design and attention to details, Gabrielle Fastman, for her careful regard for my writing, and Elinor Carucci, whose beautiful essay captured the essence of my work. I am grateful, of course, to my sons, Ben and Sam, who embody love and light, and to my husband, Harry, who knows every image.

Biographies

CAROLE GLAUBER:

Carole Glauber is one of few photographers who is also a published photo historian, a combination that influences her work. Her photographs have been included in many group and solo exhibitions worldwide, and she has received numerous awards for her photography and photographic research. These honors include the International Photography Award, the Julia Margaret Cameron Award, the Tokyo International Foto Award, the Mobile Photography Award, the PHmuseum Mobile Photography Prize, and the Pollux Award for her photographs, as well as the Peter E. Palmquist Historical Photographic Research Fellowship, the Winterthur Museum Fellowship, an Oregon Humanities Research Fellowship, and a National Coalition of Independent Scholars grant for her photographic research. She has lectured and written about photography, and her essays have been published in the *Photo Review*, the *Oregon Historical Quarterly*, the *Oregon Encyclopedia Project*, and *The Cambridge Dictionary of Judaism and Jewish Culture*. Glauber is the author of *Witch of Kodakery: The Photography of Myra Albert Wiggins* 1869–1956 (Washington State University Press,1997).

ELINOR CARUCCI:

Artist Elinor Carucci was born in Jerusalem in 1971. Her work has been included in numerous solo and group exhibitions worldwide, and has appeared in publications internationally. Her work is in the collections of MoMA, the Jewish Museum, the Brooklyn Museum, and many others.

She was awarded the ICP Infinity Award in 2001, a Guggenheim Fellowship in 2002, and a NYFA Fellowship in 2010. Carucci has published four monographs to date: *Closer, Diary of a Dancer, Mother*, and, most recently, *Midlife*.

Carucci currently teaches at the graduate program of photography at the School of Visual Arts and at the International Center of Photography. She is represented by Edwynn Houk Gallery.